GHOSTOGRAPHS

ADVANCE PRAISE

"Maria Romasco Moore's astonishing *Ghostographs* is an incantation, an elegy for the distance between life and death. It's the sound one hears if one is lucky enough to perceive the chatter of ghosts, their magical cataloguing of what was and is. This is more than a novella, more than a book; it's a living object that pulls you into its loop until it's also yours, and you live there, too."

—Lindsay Hunter, author of *Eat Only When You're Hungry*

"Every so often I'm lucky enough to stumble across a debut by someone I immediately know will become one of my 'everything writers'—a writer, that is to say, whose sensibility is exciting enough and whose work is original enough that I realize I'm on board not only for the book in my hands but for every book that follows. Maria Romasco Moore is such a writer, and *Ghostographs* is such a book: unique, beautiful, refined, and surprising."

—Kevin Brockmeier, author of *The Illumination*

"Maria Romasco Moore's *Ghostographs* gives me the same feeling I experienced years ago when I first encountered the gorgeous, gruesome art of Edward Gorey. These stories in miniature leave me feeling both thrilled and horrified: horrified to be so thrilled, and thrilled to be so horrified. All my life I've wanted to encounter a real ghost, and now it seems I've come to know a whole town full of them."

—Pinckney Benedict, author of *Miracle Boy and Other Stories*

GHOSTOGRAPHS

AN ALBUM

By Maria Romasco Moore

Rose Metal Press

2018

Rose Metal Press, Inc.

P.O. Box 1956, Brookline, MA 02446

rosemetalpress@gmail.com

www.rosemetalpress.com

ISBN: 978-1-941628-15-7

Cataloging-in-Publication Data on file with the Library of Congress.

The following is a work of fiction. Any resemblance to actual persons, living or dead, or actual events is purely coincidental.

The author would like to thank the editors of *Necessary Fiction* and *The Collapsar*, where "Mabel" and "My Father," respectively, first appeared.

Photographs throughout are found art from the collection of Maria Romasco Moore.

Cover and interior design by Heather Butterfield

See "A Note about the Type" on page 80 for more information about the typefaces used.

This book is manufactured in the United States of America and printed on acid-free paper.

To Mud

TABLE OF CONTENTS

PREFACE

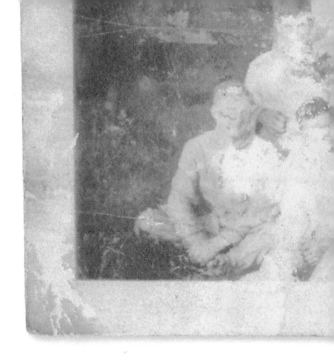

Every story is a ghost story.

Even the ones you tell about yourself.

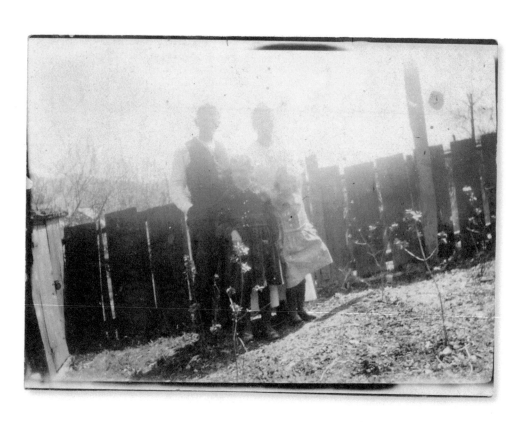

When I was little I believed that the person I was today and the person I was yesterday and the person I would be tomorrow were three separate people.

I believed that I lived only one day. In the morning I was born and in the evening I died and the person who awoke in my bed the following morning was someone new.

I believed that this cycle continued day after day, the variances between iterations subtle enough as to be nearly imperceptible, but each iteration nonetheless distinct from its predecessors and descendants.

Like frames in a film, this succession of discrete individuals appeared from a distance to be continuous, but upon closer inspection was clearly divided by regular intervals of darkness, of nothingness, which most people mistakenly referred to as sleep.

This was a childish belief, of course.

The truth of it is that every single instant we are, all of us, obliterated and refreshed.

In the time it takes to blink or turn around, you have become someone new, separate from the originator of the action, who is gone now forever.

A brief conversation between yourself and a stranger is, in reality, a hundred some snippets of sound passed between a hundred some strangers and a hundred some versions of you.

And if, at a later point in time, you choose to relate this conversation to a third party, you are telling the story of people long gone. You are telling the story of ghosts.

These are mine.

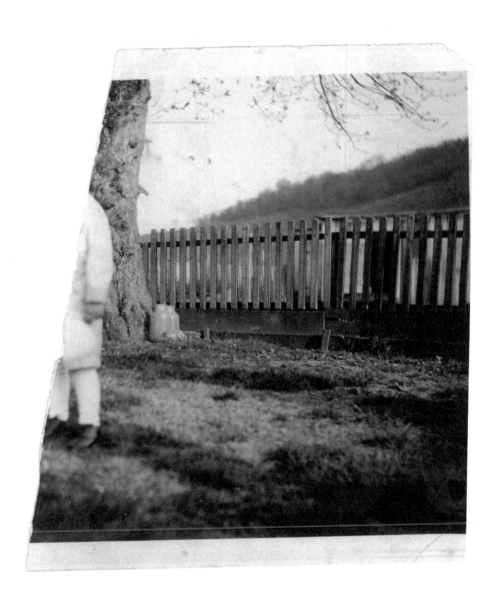

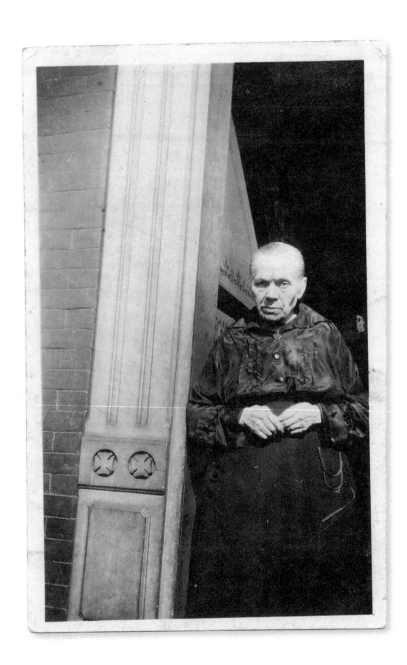

THE WOMAN ACROSS THE WAY

Underneath her skin there were snakes. I saw them once, writhing along the backs of her hands.

My mother made too many muffins, so she sent me with a tin to give to the woman across the way. We'd never seen her, but we heard she lived alone.

The snakes were thin and greenish blue and I know what you are going to say. *Those were veins*, you are going to say. *Silly child, don't you know what veins are?* But I tell you they were snakes.

I tell you that as I handed her the tin, my hand brushed against the back of her hand and I felt the prick of their teeth, needle sharp, on my palm.

At the county fair that year, she had a quilt up for raffle. It was made of scraps no bigger than postage stamps. Everybody marveled at how a woman so old could make stitches so fine and straight and small. But I knew how. She had the snakes sew it with their teeth.

I bought four tickets for the raffle, but I didn't win. In the baking contest, my mother's muffins got third place.

THE BRIDGE OVER THE ABYSS

We liked to throw pennies off it and then listen. You might think it would be boring, waiting for a sound that never came, but it wasn't. I guess we never stopped believing that if we just waited long enough we'd hear a distant clink.

We were proud that a town as small as ours had an abyss of its own.

True, every now and then someone would jump off the bridge and then someone else would say, *We've got to do something about the damn thing. Think of the children.* And then everyone would think about us for a few days. We would think about ourselves, too, and about what it must feel like to fall forever. It didn't seem so bad to us. Like my mother always said, there are worse ways to spend your time.

The people who went over the railings were missed, to be sure, but they were never truly mourned. There was too much uncertainty. It seemed possible that if we just waited long enough, we would hear them, calling up to us from a long way down, calling up to tell us what they'd found.

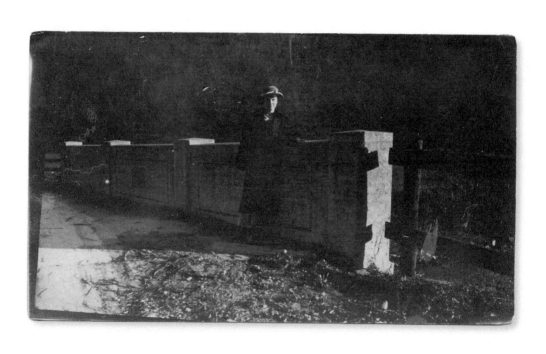

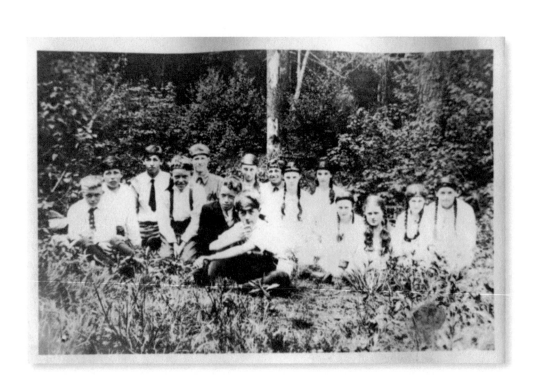

W E

We moved in packs, mostly. Our territory was well defined. From the far bank of the river to the bridge over the abyss. From the hollow fallen tree in the middle of the forest to the top of the flagpole. From the froth at the bottom of the waterfall to the castle. From my backyard to yours.

We were feared by a few, but misunderstood by most, mistaken for harmless creatures, soft and small, toothless and tame. We did what we were told sometimes, but only because we chose to.

In the winter we dug burrows in the snow, hunkered under blankets of frost, stored up sleep for the summer. At school we dozed with eyes open. Spoke nonsense when called on to answer questions.

In the summer we never slept and no one could stop us.

HIDE AND SEEK

Those were the perfect summer days. Days when the sunlight stretched on forever and even the darkness was just condensed light, burnt black in the heat. On those days we did not think of winter because we knew there would never be another winter. The world would end before the season was up. It was the only thing that made any sense.

In the evenings, by unspoken agreement, we would gather in the middle of the street and play hide and seek. There was no home base and no out of bounds. You could hide under the river if you dared. In the dark, we all held our breath, stifled coughs and sneezes, hoped the thrumming of our own blood would not betray us.

The game ended when everyone was found, or when the sun rose, whichever came first.

One year, old Mrs. Randolph died, and when her children came to clear out the house, they found Jimmy Hodgkin under her back porch. He'd been hiding there for almost a year, drinking from her hose and eating scraps out of her compost bin. He was quite pleased with himself for not being found, but the truth is we had just forgotten about him. He was a very dull boy.

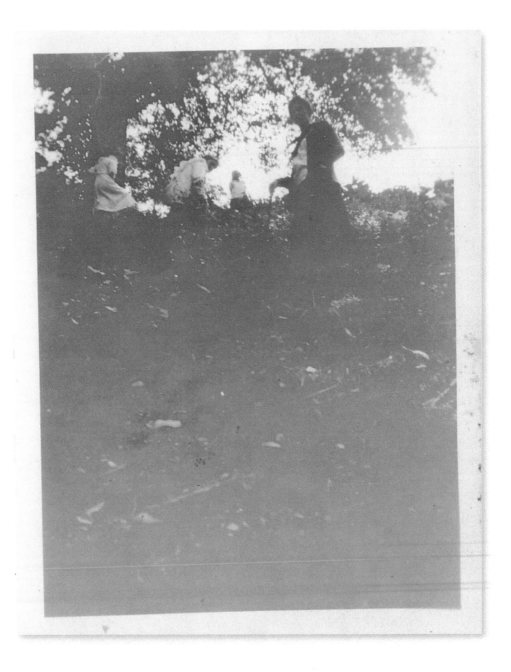

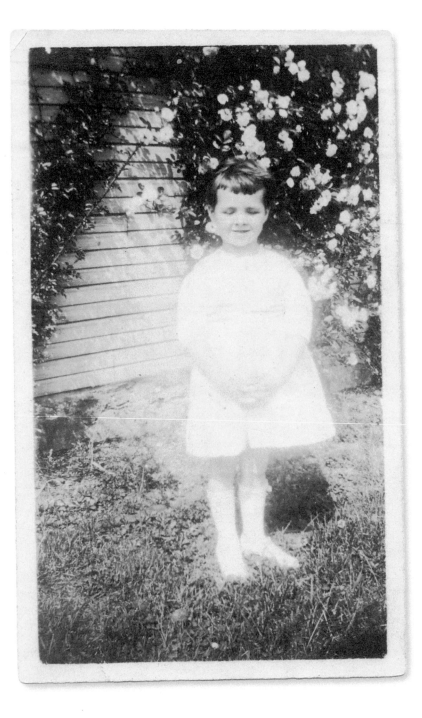

TESS

They always said, *Let the light of the Lord shine through you*, but when she did just that they couldn't take it. You should have seen the fuss they made. Exorcisms on the hour every hour.

We all hated her, how smug she got in a darkened room.

Her mother put her out on the porch at night. She shone brighter than the streetlamps. Moths migrated from miles around just to throw themselves at her. At her birthday party that year, we had to cover her with a tablecloth. It hurt our eyes to look straight at her.

She was so bright that if you held a book in front of her face, you could see every single page all at once. You could try to read the book that way, but it would make no sense. If you held your own hand over her hand, you could see all the muscles and veins and bones and the old rose thorn lodged under your left thumbnail. You could read your hand that way.

They tried immersing her in the river at midnight, rubbing her skin with coal from a mine disaster, locking her in a lightless room for hours, but she shone on despite their efforts.

She switched off of her own accord one morning. It was a great relief. We all had a lot fewer headaches after that.

LEWIS

My friend Lewis said that there were people growing out there in the tall grasses. He said he had seen them many times, whole groves of them, swaying in the breeze. I said maybe they were the ghosts of picnickers who'd been devoured by ants, but Lewis said that was foolish.

They grew, he insisted. *Up out of the ground, just as a cornstalk or a dandelion does.*

Why, then, had he not picked one, I asked. It seemed to me the logical next step, if what he told me was true. He said, *You can't get close. There are thorn bushes all around them, hidden in the tall grasses. You would bleed to death before you got within ten feet.*

That sounded like an exaggeration, but he showed me the scars on his legs from the thorns, so I had to believe him.

What do they do out there all day? I asked. But he said they did absolutely nothing. Just grew.

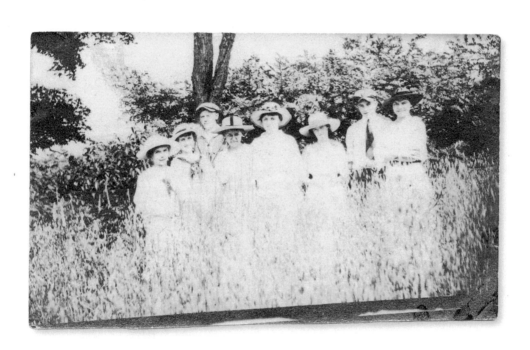

R H O D A

Opinions were evenly split. Half of us believed that she did not know, and half of us believed that she knew perfectly well but didn't care. No one could say for sure, but everyone had some evidence to offer.

Someone saw her bathe it in a mud puddle. Someone saw her hold it close to her chest. Someone saw her feed it a rotten banana. Someone saw her suckle it at her own bare breast.

Once some troublemakers stole it and replaced it in the cradle with another, identical as far as they could tell. But Rhoda noticed right away. Of course she did. She was distraught. We all helped her search, regardless of our opinions. In the end, it was discovered rooting happily in a trash bin behind the diner on Main Street, completely unharmed.

Lewis saw her holding its front trotters in her hands, trying to teach it to walk on two legs. Tess saw her walk it on a little rope leash. My mother saw her reading to it from a book about the North Pole. A farmer saw her suckle it at his prize sow's teat.

The one thing everyone could agree on, even the troublemakers: she loved that thing as if it were her own.

I saw her stroke its soft ears. I saw her wipe its sweaty brow. I saw her hold it close to her chest. I saw her know or not know, doesn't matter.

THE TROUBLEMAKERS

Most likely their mothers didn't love them enough. Or maybe they loved them too much and the weight of it was crushing. Either way, the end result was the same.

Milk bottles missing from porches. Roses uprooted. Ink blots on the bedsheets. Sand in the saltshakers. Fine china teacups shattered in locked cabinets.

Babies let loose from the bonds of bassinets. Little sisters liberated from the burden of pigtails.

We all bemoaned their obstinacy, their insolence, their refusal to comply with the simplest of unspoken social contracts.

In truth, though, we were all troublemakers sometimes. It came on like a fever—the urge to wreak havoc, the desire to manufacture disorder. The need to take ahold of some small piece of the world and then move it—ever so slightly—out of place.

To reaffirm in this manner the baffling fact of our own existence, tenuous and ephemeral as an unwatched crystal punchbowl. To assert some modicum of control over the vast and inconsiderate universe, stretching as it did far beyond the limits of our comprehension. To prove to the world that we mattered, that we were there once, scissors in hand, and that afterward everything was different, that afterward nothing could ever be the same.

To make our mothers sigh.

HANNAH

One summer, Hannah, the postman's wife, sent away for a mail order baby. It arrived about two weeks later wrapped in fourteen layers of foam. Hannah checked it all over for damage sustained in transit and found it to be fully sound.

It was a good fat baby with red cheeks. We were all fascinated by it at first. We took turns poking it in the legs to see if it would giggle. It usually did. Sometimes we pinched it to see if it would scream. It usually did that, too. It was very obliging.

We lost interest after a while. It didn't seem much different than other babies. At least, that is, until the day it learned to crawl.

From then on, the baby was constantly creeping into bicycle baskets and clinging to the brims of oversized hats. It crawled into the glove compartments of cars and onto the backs of trucks. Three times it made it to the bridge over the abyss before anyone noticed. That baby was restless.

The postman started letting it ride around in the mailbag, and that calmed it down a bit, but still, one day it crawled onto a train and got halfway across the state before a conductor discovered it.

Can you return it? we asked Hannah. *Get an exchange or a refund?* But she said no, even if it was defective, she'd grown rather fond.

MY GREAT AUNTS

I had more of them than was strictly necessary. Everybody said so.

True, Aunt Ruth brought bags of saltwater taffy back for my little sister and me every time she went on one of her trips to the seaside. And, yes, Aunt Cecily gave excellent life advice. And, sure, I will always remember with fondness the day Aunt Edna took me out in the woods and showed me where the bodies were buried.

But it took a toll, too. I had trouble keeping track of them all, trouble remembering which took cream in her coffee and which took whiskey. They did not take kindly to being forgotten. It was imperative that my sister and I send every one of them handmade and heartfelt cards on their birthdays and on the anniversaries of their weddings and on the anniversaries of their husbands' deaths.

They pinched our cheeks until we bruised. They shamed us for our untied shoes. They knitted us hideous sweaters, which itched worse than anything. They loved us, certainly, but not like their own. More like dolls, or tiny dogs.

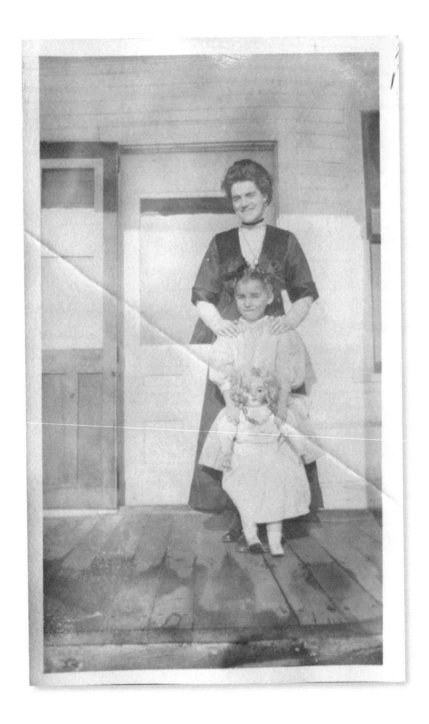

DOLLS, OR TINY DOGS

Aunt Cecily had quite a lot of both. You walked into her house, and it was nothing but eyes. Looking up at you from the floor. Looking down at you from the shelves on the walls. And Aunt Cecily's own set, of course, somewhere in the middle of it all.

We assumed the dolls were haunted. We could see no purpose for them otherwise. But they never once moved on their own, even when we turned our backs specifically to trick them into it.

It was the tiny dogs who were haunted. Not all of them, but a few. There was a Miniature Schnauzer that was haunted by the ghost of Aunt Cecily's first husband. This dog was her least favorite, to hear her tell it, but she let it watch the television all day long and fed it cigars with mustard on rye.

My favorite was a terrier haunted by the ghost of a Great Dane. That dog barely came up to my knees but you could tell that, in its heart, it towered over all of us. I wanted that dog for my own. Once, Aunt Cecily let my little sister pick out any doll she wanted from the whole house. I hoped she'd let me do the same with the dogs. But instead one day she offered me a doll, too. I said, *What in the world would I want with a doll?*

Aunt Cecily said, *Child, if you live long enough, you will learn the value of a set of eyes that do not watch you and a pair of lips that never speak.* So I picked out a small porcelain doll with a chip missing from her cheek. I put her on the shelf in my room and I never bothered her and she never bothered me either.

THE CASTLE

It wasn't really a castle. It was only a house. We just called it a castle because of the high stone walls and the moat all around it and the big spiked portcullis in the front.

Aunt Edna and Aunt Ruth moved in there the year after both their husbands died. That was before I was born. Everyone said it was much too big a place for two ladies alone, but they managed. Said all that space gave them room, for once, to breathe.

It was the perfect place for hide and seek. It had narrow corridors and spiral staircases and turrets and ramparts and a garden with a maze made of rosebushes. My little sister and I once spent three days making a map of it, but we barely covered half. Aunt Edna admitted that there were rooms she'd never been in. Aunt Ruth claimed she'd seen every room, but allowed that she was always losing track of them and that there were quite a few that, having stumbled upon them once, she could never find again.

The problem was that the castle was shrinking. Every summer it got a little bit smaller. The moat had once rivaled the river, but by the time my sister turned five it was merely a trickle. Aunt Ruth would tell us about all the rooms that had gone missing for good. *Used to be a big pantry here*, she'd say. *Used to be a pleasant little parlor, but now there's just a niche.* Aunt Edna said it was in the nature of real estate to depreciate. My mother said that the castle was never that large to begin with. She said it only looked that way. A trick of the light.

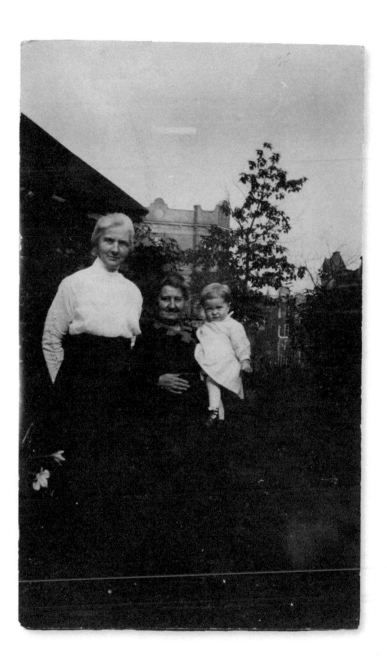

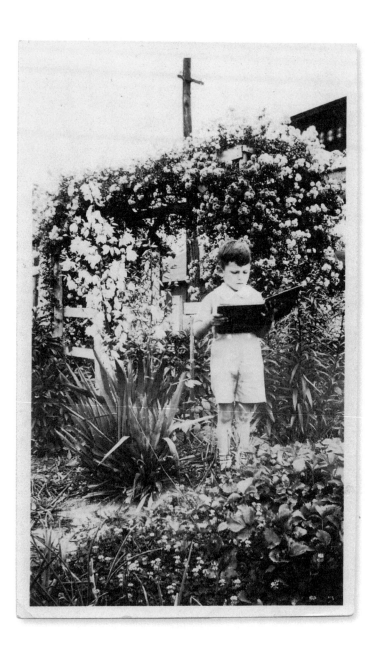

GOD IN THE GARDEN

Grandpa said that seeds were vulnerable to Satan in their nascent state. Only by singing hymns to them daily as they slumbered under covers of dirt could we entice them to grow upward.

In school, the teacher told us that all plants grow upward regardless of circumstance, but Grandpa said that was hogwash. He said some plants grow straight down into the earth. Those ones were already past saving.

Don't plants need light to grow? I asked him. He laughed and said, *Sure they do, but there are a lot of different kinds of light in this world.*

So I sang.

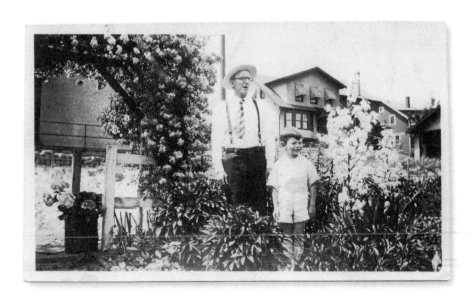

DIFFERENT KINDS OF LIGHT

There is the light that lit up Tess and there is the light of a lamp, and Grandpa told me these are different, though you might not know it to look at them. There is the light that lit up the river after the lightbulb factory opened and there is the light that bubbles up from the bottom of a well sometimes, from a place deep inside the Earth. That light is blue and it blooms like a flower when it reaches the surface. Grandpa said he was one of the few people in the world who'd ever been lucky enough to see it.

You've got to be careful with light, he told me. Some of it is shadow in disguise. Some of it isn't light at all, but merely the absence of darkness. Some of it can burn you. Some of it is colder than ice. Ice casts a light, as does stone. Some light is dangerous. Some light is safe. Be careful of the light that filters to the ground through a dense layer of tree leaves. Sometimes it changes shape on the way down. Some light is okay to drink, but some will make you sick. Some light can only be seen by the blind. Some light can blind you. Some light has restorative properties. Some light is cast by ghosts for nefarious purposes. My grandpa taught me all this and more.

If you are ever unsure what kind of light you are dealing with, he said, *check to see if a cat will sit in it. If so, it is simply the light of the sun.*

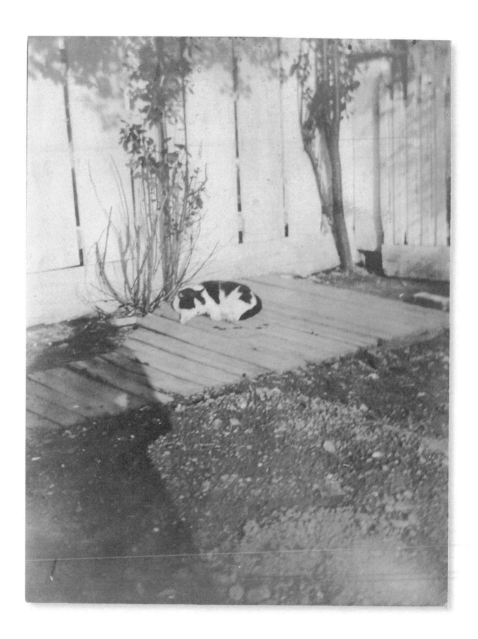

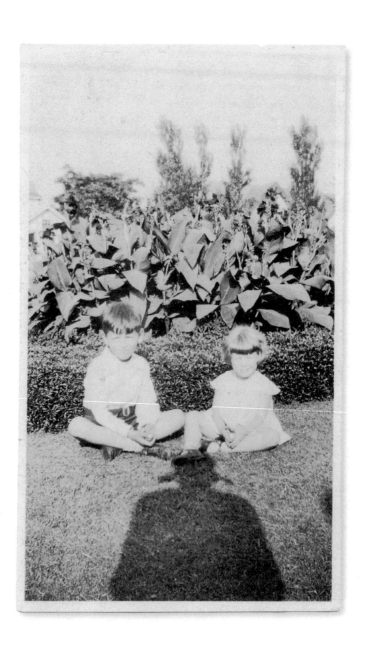

AUNT BERYL

I've met her many times, but I couldn't tell you what she looks like. I never once got a good look at her face.

She had this knack for standing backlit, blotting out the sun with her floppy felt hat, casting her features into shadow, like a one-woman eclipse.

I guess she was never around on overcast days. Or else the days were never overcast when she was near. She managed it inside, even, always framed by a well-positioned window, floppy felt hat limned with gold.

It was strange to talk to her, to be so unceasingly unsure. Was she smiling? Was she scowling? No way to know. Could be she was pulling funny faces all the time. Could be she had no face at all. Just a blank space where a face should be.

She wasn't the worst of my aunts, nor was she the best. In my memories of her, it is the hat that stands out most. I would recognize that hat anywhere.

I could never tell what Aunt Beryl thought of me. But the hat always seemed kind.

THE RIVER

For as long as anyone in town could remember, there had been a problem with runoff from upriver. It used to be nothing but dairy farms up that way. Come spring, my mother told me, the river would be all milk, a bright white ribbon winding through town. In the mornings, people would send their kids out with thick glass bottles to collect some fresh for breakfast.

As the years passed, the farms were bought up and turned into factories. There was one factory that made the same kind of bottles those kids had used to collect milk. Come spring that year, my mother told me, the river was all molten glass, flowing slow and clear as a window.

Those early factories never stayed open for long. Every spring brought something new—irregular jeans floating bloated down the river like the bottom halves of bodies, clusters of caramel popcorn bobbing along like tiny clouds. One year a vat of copper-kissed crimson sprung a leak at the hair dye factory and everyone thought it was the end of days.

The year that the medical testing facility moved in was among the best. Come spring, anybody feeling a bit off could simply take a dip in the river and be instantly healed of every illness they had, as well as quite a few they didn't.

That was a sorry year for doctors, to be fair. They had to content themselves with treating people who felt just a little too well, a little too much like themselves. Who felt like maybe something was missing, now.

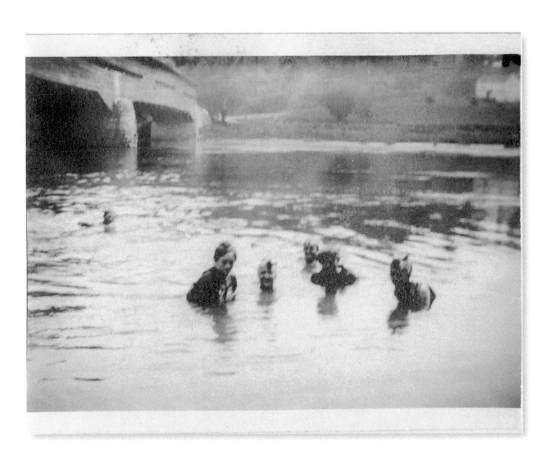

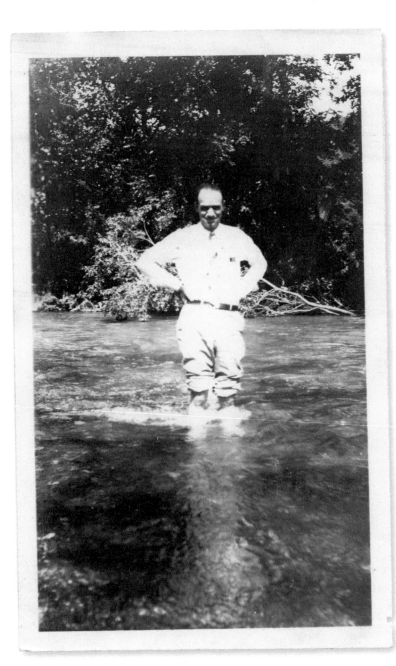

MY FATHER

The fish were all dead, of course. Not much could survive in that river from year to year. So my father made his living fishing for phantoms. Salmon mostly. Some perch.

He'd bring them home in a big metal bucket with a heavy lid. Once I tilted up the lid to see them, swirling around the bucket in circles, scales translucent, bones silver. But I looked too long and before I could shut the lid again, they all darted out and swam away into the sky. Except for one, which swam into the forsythia bush, where it was promptly caught by a cat.

My father sold his fish ghosts to the butcher, who knew how to prepare them, but my father was the only one who knew how to catch them.

Nobody could figure out how he did it. Ghosts are slippery things. Any number of us tried to follow him down to the river, learn his secret, but we'd always lose track of him somehow on the way. My mother said that was a trick of the light.

The whole thing was a trick, my mother told me. He didn't really fish at all. He just went under the water with that bucket, told all the ghosts he had something to show them. Tilted the lid, said, *Here, come closer. Take a peek.*

MABEL

She slept all summer and only woke up when it snowed. We'd all spot the first flakes of the season drifting down outside our windows and think to ourselves, *Oh good, it's been so long since we've seen Mabel!*

She wore a velvety black jacket made from the skin of something. Lewis thought it was a bear, but I thought it was probably the skin of the night sky.

She baked the best bread of anyone. She told us the secret ingredient was a cupful of snow gathered before it hit the ground. I had my mother bake a loaf once, but she used snow that had already fallen, and it wasn't as good.

Mabel had a small cabin built out in the woods. She shot anyone who came near it in the knee. She could shoot a bird flying south from two towns away. Most parents told their kids not to go near her. She was dangerous, but that's why we liked her.

She smoked these thin cigarettes, and instead of floating away like normal, the smoke got tangled up in her hair and stayed there, so she was always walking around in a cloud.

When the first crocus buds starting gawking up out of the ground, shaky-headed and shy, she stalked back to her cabin and stayed there. Said she couldn't stand anything tender.

THE MAN AND THE CORNSTALK

The man told everyone who would listen that the cornstalk was his dead wife. It was a very tall cornstalk. The man's wife had been dead for about five years.

I asked Lewis if this was the same kind of thing as the people growing out in the tall grasses, but he said no, it wasn't the same thing at all. He said that was a stupid question.

My mother said that people who are grieving deserve a little license. She told me I should leave the man alone, and the cornstalk, too.

The man was very wary of troublemakers. He trained a stray dog to keep watch over his wife while he slept. He rigged up a makeshift fence from broken bottles and empty cans. He was going to build a wall around his wife. He was going to build a house for her, with a ceiling of glass so the sun could still come through.

But the man couldn't afford to build a house. Every cent he got was spent on bottles, which he drank and added to the fence. After a long time of just drinking from bottles and not eating, the man dug a large hole at the base of the cornstalk. Then he laid himself down in the hole and died.

The cornstalk thrived.

MY MOTHER AND MY SISTER

They'd go away sometimes, just the two of them. I never knew precisely where. When my sister was very young, they'd only go for a day or so. But as she got older they'd stay away longer. A week, sometimes. Two.

They'd return with mud on their boots, sand in their hair, burrs clinging to their skirts. Sometimes their faces would be sunburnt pink or their palms crossed with small cuts. Once, when my mother took off her boot, a tiny scorpion crawled out. My mother sighed and rubbed her heel. I caught the scorpion in a jam jar, but it refused all food and I had no choice but to let it go.

I didn't mind these absences. In fact, I liked them. My little sister was a pest sometimes, my mother prone to lectures. My father worked down at the river all day, so I'd get the place to myself. I could swing from the rafters, dance on the dining room table. Eat what I pleased. Bathe rarely, if at all.

But the longer they were gone, the more I learned how much work it took to keep the house. When the roof leaked, I patched the holes with chewing gum, but my jaw grew sore and I nearly fell off the ladder. When I ran out of peach preserves (which I'd been eating straight from the jar with a spoon) I had to teach myself to cook. When the basement flooded, when the foundation cracked, when the raccoons moved into the spare bedroom and refused to leave. Well, I started to miss my mother and my sister. Started to wish they'd hurry back.

Yet even when they returned, when they went about their lives as usual, I could tell by the way they stood next to windows for too long, gazing out, that they were only waiting for their next chance to go.

TESS UNLIT

She wasn't so smug when it was all over. When she blinked out like a burnt bulb, there was no consoling her.

In the weeks that followed, she spent hours lying in the grass with her stockings off and her sleeves rolled up, trying to soak the sun into her skin. It did no good, just bleached her out like the old floral curtains in Aunt Cecily's kitchen window, the ones with the primroses pale as ghosts.

Tess stuck her fingers into electric sockets. She stood on the roof during thunderstorms. She ate a couple of fireflies once. Lewis saw her do it.

I told her to look on the bright side: she was much better at hide and seek now. But the word *bright* made her cry. So then I told her what my grandpa said about the different kinds of light. She said that was silly.

All the same, she quit fighting it after a while and just faded, little by little, year by year, so slow you almost couldn't see it. And then one day you couldn't see her either.

From then on, she won every game of hide and seek. We weren't always sure that she was actually playing. We could never be quite sure that she was even there. But we assumed she was, just to be safe.

AUNT MILLIE

She spent a long time dying. You'd say, *Hey Millie, how you doing?* And she'd say, *Oh! I'm knocking on death's door. It won't be long now.* That went on for a decade or so.

She didn't get serious about it until the year my little sister turned ten. That spring she confined herself to her bed and hired two nurses to watch over her.

There doesn't really seem to be anything wrong with her, one of the nurses confided to us, *but she pays well*. We indulged her, brought her flowers, held her hand while she dictated revisions to her will. We did our best to look sad, even though we didn't believe she would truly be leaving us.

A few months in, however, her condition began to change. Her skin grew pale, her vital signs erratic, her speech disjointed and strange. The nurses were forced to admit that perhaps she was dying after all.

I can't believe it, cried my mother, *she's fading away before our very eyes*.

My mother was wrong, though. When I looked at my great aunt I did not see something diminishing, but something emerging from where it had long been buried.

The nurses quit soon after, and the family had Millie sent away to a state-run place. I think they all saw it, too. I think they were afraid.

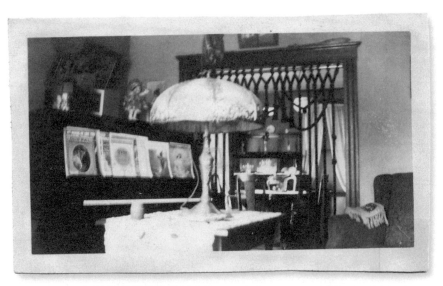

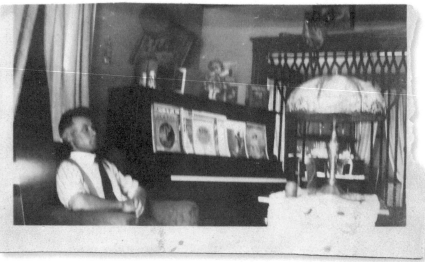

THE MAN AND THE LAMP

There was another man in our town who got into a staring contest with a lamp. Nobody I asked could say how the contest began. They only knew that it had, and that as far as they could tell, the two were evenly matched.

We spectated sometimes. The man's sister would let us in on the condition that we be very quiet and very still. If we so much as sneezed, we'd be kicked out. It was imperative that nothing break the man's concentration, or the lamp's. They both wanted a fair fight.

Back when Tess was all lit up, we talked about nicking the lamp so we could hang the shade on her, but there was no way we would have been able to get away with it. The man slept with his eyes open every night.

Years later, I heard that the contest had ended. The man's health had been failing for a while, and people were placing bets on the lamp left and right. Then a freak storm blew in from the coast and a bolt of lightning struck a telephone pole. The wires were fried. The lamp lost.

The man perished less than a week later. The official cause of death, according to the coroner, was a sudden lack of purpose.

HIDE AND SEEK

One morning the sun rose sort of pink and fuzzy above the rooftops, and our game of hide and seek was over. I was the seeker, and I'd found everyone but my friend Lewis (and Tess, of course, but that goes without saying). Everyone knew that Lewis was one of the lousiest hiders out there, so after that I got a reputation as a lousy seeker, too, which I thought was unfair.

I was pretty sure that Lewis had cheated. He usually just hid behind a tree or under a pile of leaves. Once he'd hid by standing in front of a stop sign while wearing a red shirt. I was planning to be very cross with him as soon as he was found.

He wasn't, though. Other seekers sought him, too. Better seekers, some would say. I started searching for him in the off-hours, during daylight, which was against the rules. I scoured every inch of our town. Even screamed down into the abyss.

Finally, I thought to check the tall grasses. He was out there all right, swaying lightly in the breeze. I ran toward him, but the hidden thorns tore at my skin until I was red all over and I had to stop.

Lewis returned to town in the winter. He'd done a lot of growing. He was over six feet tall. I could no longer look him in the eye without a ladder. He bummed cigarettes from Mabel and leaned against the sides of buildings like a fallen tree.

I thought to myself: *my friend Lewis is gone now. I lost him in the tall grasses and he'll never be found.*

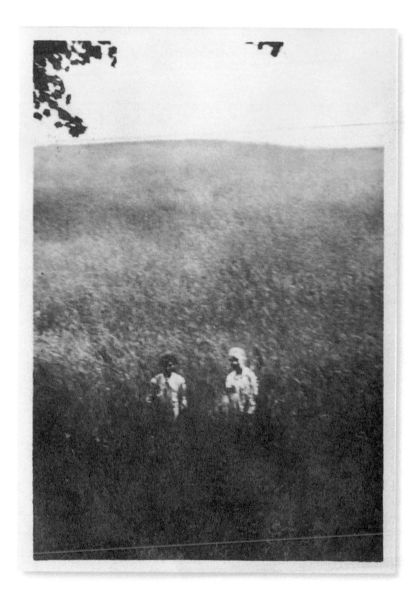

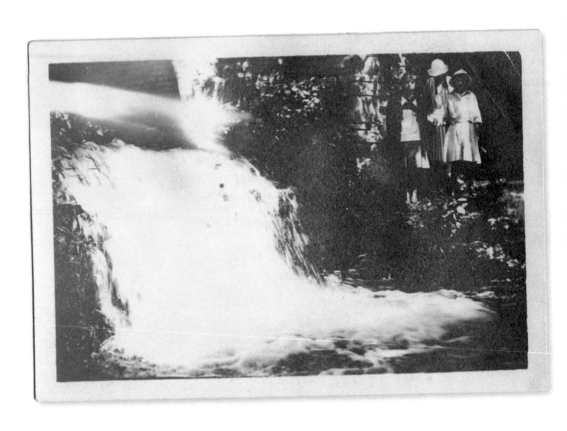

THE WATERFALL

My mother said the waterfall was full of ghosts.

They all died upriver originally, but their spirits floated down and got tangled in the falls like smoke in Mabel's hair. Except this one ghost, who drowned in the waterfall itself.

Never wash your hair in a waterfall, my mother said, *no matter how lustrous legend says it will become. It's not worth it and people will think you are vain.*

Look both ways before you cross the street. Brush your teeth. Check that the water in the river is actually water before you swim. Don't bother frogs.

My mother said, *Never fall in love with a ghost, no matter how tempting.* She told me this was a very common problem.

She said sometimes a person will fall in love with the ghost of someone who isn't dead yet. Usually, the person doesn't even realize that they are in love with a ghost. They will waste their life on that love. They will clean up after the ghost, and cook for the ghost, and spend every night sleeping next to the ghost, and even have children with the ghost, but there will be something off about the children, something unfinished. And one day this person will realize that the person they loved never even existed, that he was only a phantom, as flimsy as a song. But by then it will be much too late.

Don't do that, my mother said.

THE BOAT

We all took turns at the oars. We'd row as hard as we could, but we never went anywhere. The boat was tied to a post on the shore. We could have untied it, sure, but where was the sport in that? Someday, we were certain, one of us would row hard enough and the rope would snap and the boat would sail away, carrying the champion to a world more worthy of such glorious strength. Or at least to the other side of the river.

When we arrived one morning to find the boat gone, we thought at first that the fabled day had come. But upon closer inspection, the break in the rope proved too clean. The work of a knife. This betrayal hit us hard. Stick fights broke out with increasing regularity. No one actually got an eye put out, which my mother deemed a miracle, but it seemed a greater miracle still when the boat reappeared one day, bobbing complacently in the current, retied to the post with a brand new rope.

After that, we took turns keeping watch. We'd report to our shifts, each of us sure that we were all that stood between the boat and the thief.

I don't know who noticed it first: river water darkening the hems of pant legs, different styles of knot securing the rope to the post each day. But soon we all saw the signs, every time we switched shifts. It wasn't one of us who was taking the boat out onto the river, but all of us. Oh, yes, even me.

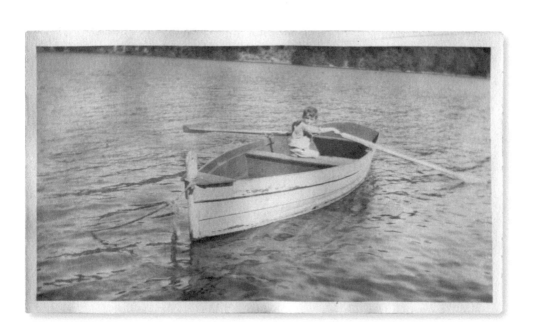

THE WOMAN ACROSS THE RIVER

People said she was a trick of the light. Well, I knew all about that kind of trick. Knew how dangerous it could be.

How many hours did I sit on my side of the river, watching her? She was always there when I arrived. Never left before I did, even if I stayed past sunset.

Her constancy was a comfort. In those long stretches when my family was absent, I would see her across the river and feel less alone. Sometimes I'd give her a little wave, but she never returned the gesture.

Until one day she did. I watched her lift one pale hand and my heart leapt. I wanted to jump right into the water and swim across. But a hardware factory had recently moved in upstream and the river was bright with nails.

So I ran to where the boat waited, untied it, rowed for all I was worth. *Well, well,* she said when she saw me, *I always thought you were a trick of the light.*

Only on my father's side, I told her.

THE THAW

It was a terrible winter. The coldest in years. The river froze solid overnight. If you looked close, you could see fish-shaped pockets of air under the surface where the ghosts had been.

So it came as quite the surprise when, halfway into February, spring suddenly arrived. The ice melted. The rooftops shrugged off their cloaks of snow. The grass blazed back into greenness. The birds that had flown south for the season came winging back all at once. But the strangest thing of all was Mabel.

Because despite the trees pushing out tentative buds, despite the fresh patches of wildflowers caressing the forest floor, despite the fat red robins hopping to and fro, despite all that, Mabel stayed.

None of us could figure it out. It went against the natural order. There were theories, of course. She was confused. She was insane. She was in love.

I finally worked up the nerve to ask her one day: why was she still here?

People change, she said. I thought of Lewis and Tess.

Not me, I said, *I never will.*

Too late, she said.

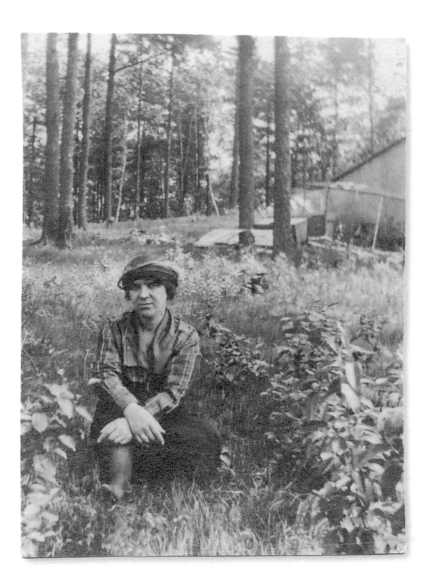

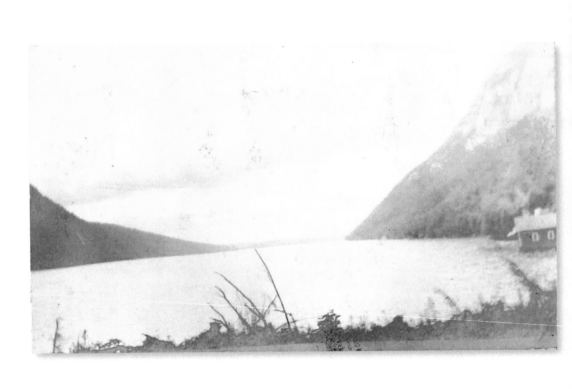

FROM TWO TOWNS AWAY

Mabel took aim and we watched the speck on the horizon drop like a stone. The smaller children crowded in, begging to know how she did it, but I was already walking.

Even when I felt the tall grasses brush against my knees and even when I felt the sting of the hidden thorns, I kept going. I crossed the river (it was only water that year) and passed into the next town over. Out of the corner of my eye, it looked a lot like ours. I passed through a second town and then into a patch of forest and that's where I found the bird.

It was a trumpeter swan, tall as a child. It stood on the ground, looking expectant and clutching a bullet in its long black beak. *So that's how she does it,* I thought. The swan spat out the lump of lead and honked. I dug in my pockets until I found an old saltwater taffy I'd forgotten. It was squashed and covered in dirt, but the swan accepted it without complaint and flew away.

Through the trees ahead of me, I could see houses and buildings, another town. So I put the bullet in my pocket and kept on walking.

HIDE AND SEEK

It isn't the sort of game you grow out of, like Tiddlywinks or Bother the Frog. We're older now, but we never stopped playing. The only thing that has changed is the rules.

The game is no longer limited to the night. We play in broad daylight now, which is stranger and more dangerous. We play all the time.

We no longer hide down laundry chutes, muffled by dirty sheets, or up tall trees, twisted through the branches like vines.

We hide, instead, in crisp suits and lace gowns. We hide beneath belated condolences. We hide behind smiles.

We turn away from mirrors. We avoid placid lakes. We duck out of group photos at the last possible second before the flash.

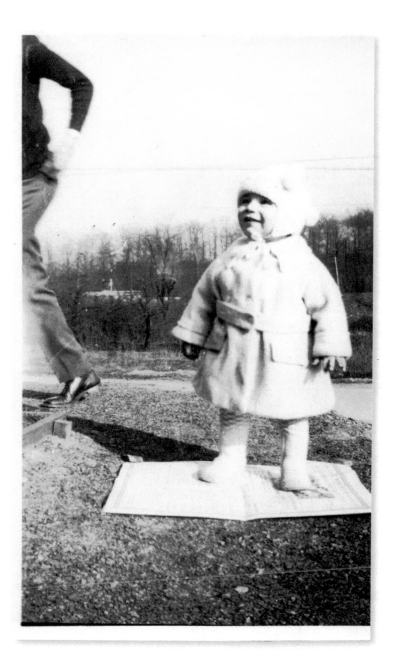

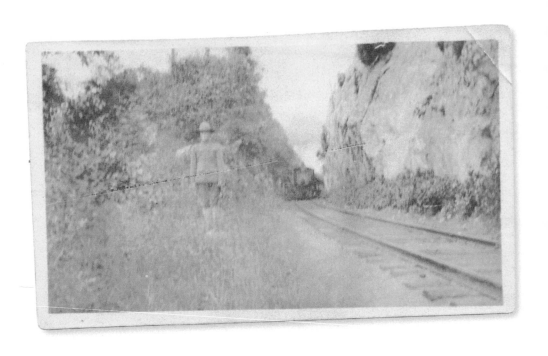

TIME

Time is a kind of light, my grandpa told me. My mother said that was typical, wasn't it? The man was late to everything. Late to his only son's wedding. They all waited for him. My mother said she had to stand there for hours, sweating in her heavy dress, batting flies away from her eyes, while my father kept saying, *Just a few more minutes, we'll give him a few more minutes.*

He'd be late to his own funeral, my mother always said. And he was.

We all stood there waiting, staring into the empty grave, which slowly filled with shadows. The hearse, it turned out, had broken down on the bridge over the abyss. The driver had to hitch a ride for himself and the coffin in the back of a pickup truck.

When Grandpa and the driver finally arrived two hours later, my mother shot me a look as if to say *I told you so* and I had to admit that she was right.

But that doesn't mean Grandpa wasn't right, too.

LIGHT

It has taken me many years and I'm not done yet. But I've learned. I've practiced. I can see much more than I used to.

The light of crickets at night. The light that filters up through the soil. The light of salt. The light that evaporates off the surface of a lake. The light you can see when you close your eyes. Where does that come from? It's as bright as anything.

Colors don't exist. They are just light having a little fun. Most of the stars don't exist. We don't exist, not the way we think we do. A photograph does not record what is actually there. Only light. Even our eyes don't show us what is truly in front of us. Only light, which, by the time it reaches us, is already from the past. But we have nothing else to go on, so we trust it.

Light dreamed us up. Light switched us on.

And like the flicker of a shutter, light remakes us every instant. Every bird. Every leaf. Every ripple on the surface of the river.

You. Me.

GHOST TOWN

The town is gone now, and all the people in it. The abyss has been paved over. The tall grasses have been tilled.

There is a new town where the old one used to be. There are new houses, new roads. They look the same as the old ones, but they are new. There is a river that winds through the town. The path it traces is nearly the same as the path the old river once traced, but it is new.

Some of the people who live in the town have the same names as the people who lived there before. There is an old woman named Mabel, and a tall man named Lewis, and a pig who walks on its hind legs and sometimes makes noises that could almost be words. But they aren't the people I used to know. The people I used to know are only ghosts.

AUTHOR'S NOTE

When I was a kid growing up in Altoona, Pennsylvania, my parents occasionally took me to an enormous antique market about ten minutes out of town. Once, while wandering through the endless rows of blue glass mason jars, dusty typewriters, tiny tin animals, ornate punchbowls, and elaborate crystal brooches, I came across a Whitman's Sampler box. I opened it, half-expecting the desiccated husks of vanilla cremes, but instead of chocolates, it was full of black and white photographs. At least a hundred of them. They were smaller than the photos I was used to, maybe the size of playing cards. They curled up at the edges. Many were faded or torn. I bought the box for five dollars.

At home, I spent many evenings looking through the images, staring at the faces of the people in them, trying to guess their stories. The box was like a mystery novel, written out of order and without a single word. Over the years, my collection of old photographs grew, thanks to innumerable yard sales and flea markets, until eventually it grew into this book.

ABOUT THE AUTHOR

Maria Romasco Moore's stories have appeared in *DIAGRAM*, *Hobart*, *Interfictions*, *Lady Churchill's Rosebud Wristlet*, and the Lightspeed anthology *Women Destroy Science Fiction*. Her first novel, *Some Kind of Animal*, will be published by Delacorte Press in 2020. She is a graduate of the Clarion West Writers Workshop and has an MFA from Southern Illinois University. She currently lives in Columbus, Ohio, with her partner Axel and cat Gamma Ray. She likes silent films, aquariums, and other tiny windows into other worlds.

A NOTE ABOUT THE TYPE

The body text of *Ghostographs* is set in Maiola, a typeface designed by Veronika Burian and released by the Czech foundry TypeTogether in 2010. The foundry describes it as "a contemporary typeface that is mindful of its heritage," which resonates with the style of Maria Romasco Moore's flash fiction and her use of vintage photographs. Maiola's letterforms have subtle calligraphic features, such as a slanted x-axis and sharp contrast, along with subtle and irregular imperfections that are intended to give it a handmade quality.

The folio ornament on the interior pages comes from the Minion family, designed by Robert Slimbach and released by Adobe Systems in 1990.

The cover uses Maiola for the subtitle and Monthoers for the title and byline. Monthoers is a vintage-style font that was designed by Agga Swist'blnk and released by the Indonesian foundry Swist'blnk Design Studio in 2015. The slightly distressed letterforms and set of swash characters, combined with its modern condensed shape, give Monthoers a timeless quality and charm befitting Romasco Moore's characters in *Ghostographs*.

—Heather Butterfield